BELOVED SPIRIT

PATHWAYS TO LOVE, GRACE, AND MERCY

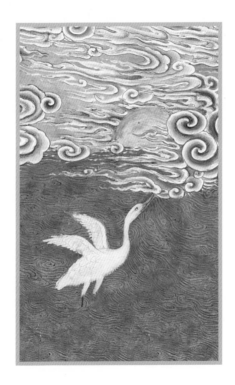

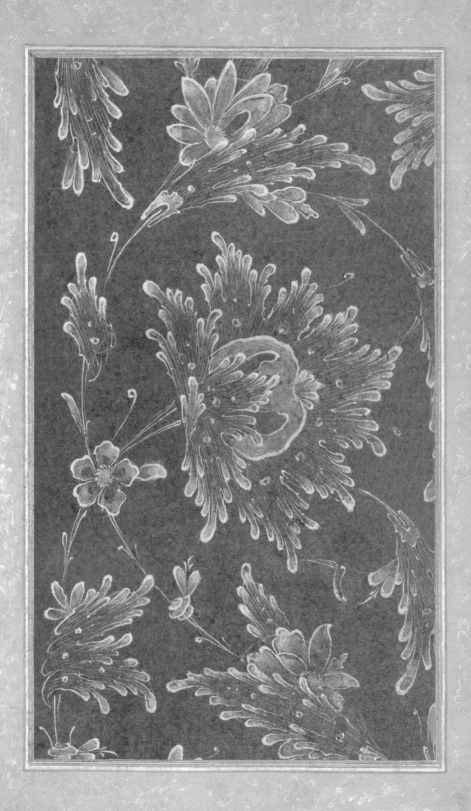

BELOVED SPIRIT

PATHWAYS TO LOVE, GRACE, AND MERCY

ALEXANDRA VILLARD DE BORCHGRAVE

PREFACE
JULIAN RABY

FOREWORD
MASSUMEH FARHAD

Glitterati
INCORPORATED

New York, New York

First published in the United States of America in 2011 by

Glitterati Incorporated
225 Central Park West
New York, New York 10024
www.GlitteratiIncorporated.com

Art Direction and Design: Alexandra Villard de Borchgrave
Mechanical Design: Marta Kapoyos
Layout: Henrique Siblesz
Photography: Neil Greentree/Freer Gallery of Art
Lettering Design: Julian Waters
Consulting Designer: Marty Ittner

Printed and bound in China

10 9 8 7 6 5 4 3 2 1

Library of Congress Cataloging-in-Publication Data

De Borchgrave, Alexandra Villard.
Beloved spirit: pathways to love, grace, and mercy
Alexandra Villard de Borchgrave;
preface by: Julian Raby; foreword by: Massumeh Farhad
—1st ed. p. cm.
ISBN13: 978-0-9823799-6-7
ISBN10: 0-9823799-6-X
I. Title.
PS E H

DEDICATION

To all those who bring comfort
to others:

In a timeless place of
no hour or land,
Where the soul is free
to seek soaring dreams,
The heart will know the
true secret of life —
To steer love to others
by gracious means.

Alexandra Villard de Borchgrave

CONTENTS

PREFACE

The events of 9/11 seared themselves into the consciousness of people across the world. For many individuals and for many families, the reactions were traumatic. For several nations the consequence was war. Even for those of us not immediately affected by the events, there was no escaping the new millennium loomed dark and fearful.

There were many who sought solace in art. At the Arthur M. Sackler Gallery over 70,000 people came in person to hear Tibetan monks intoning, as others created a giant mandala from tiny grains of colored sand. Our grasp of time is now, like so much else, governed by an unseen digital realm, but we still refer, in tones that often smack of a lament, to the "sands of time", and here the Sand Mandala took us from the painstaking construction of a sacred landscape to an instant of dispersal, as the sands were swept up and thrown into the waters of the Potomac, to spread their blessing far and wide. The ritual of creation and annihilation struck deep with many who had never encountered Tibetan Buddhists before. The event was moving as the thousands who came sought not so much to understand the details of the Buddhist ritual and its meanings, but to find their own meaning in a world that had seen its certainties so brutally shattered. The completed mandala they recognized as one way of visualizing eternity, the mandala's brief existence as an allegory of our tenuous grasp on human life.

Alexandra Villard de Borchgrave's response to the events of 9/11 was to turn to poetry as both catharsis and communication. Determined to spread a message of hope in a bleak world, she formalized that communication in her first book, and now, less than a decade later, she has produced three books. In each she has made her own journey in words, but she was equally determined to find a visual complement. The first book was illustrated with figural images drawn from Indian and Persian manuscripts, the second with Japanese calligraphy and decorative designs. In this third book she has excerpted details from one of the most famous illustrated Persian manuscripts, in a manner that discards the literal or the descriptive in favor of mood. In moving from her first book to her third, she has abandoned narrative for spirit. Yet the images form a sequence that has an over-arching narrative, as they follow the light and shades of a passing day, reminding us that, like all creatures, we are in this world for a fleeting moment.

Julian Raby
Director
Freer Gallery of Art and Arthur M. Sackler Gallery of Art

FOREWORD

One of the greatest masterpieces of the Freer Gallery of Art
is an illustrated copy of the *Haft awrang* (Seven Thrones
or Constellations) by the Persian poet and scholar Abdul
Rahman Jami (died 1492). The seven mystically inspired
poems are interspersed with allegorical romances and moral
parables, which help explain some of Jami's complex and
abstract ideas. In turn, these stories have inspired many
highly accomplished painters to create their own pictorial
interpretations and elaborations of Jami's work. In 1556,
Sultan Ibrahim Mirza, the nephew and son-in-law of the
Safavid ruler of Iran, Shah Tahmasb (reigned 1524–76)
commissioned the most lavishly illustrated and illuminated
copy of Jami's *Haft awrang*. The young prince engaged five
leading calligraphers, several painters, and illuminators
to work on his manuscript, which took some nine years to
complete. Every folio of this exceptional volume is written
on fine gold sprinkled paper and set into colored margins,
decorated with illuminated designs of swirling leaves and
blossoms or geometric motifs. The manuscript's twenty-eight
sumptuously painted compositions complement Jami's richly
nuanced poetry in their refinement and complexity, but often
also expand and embellish on his words.

This subtle interplay of word and image, a cornerstone of
Persian arts of the book, is also central to *Beloved Spirit*, the third
volume in Alexandra Villard de Borchgrave's poetic anthology.

Over the past decade, Ms. Villard de Borchgrave has successfully drawn on the Freer and Sackler collections for what might be called her project of consolation and hope. In her introduction to this volume, she describes the genesis of her elegantly conceived and intimately scaled books, which were inspired by the tragedy of September 11, 2001 and the world turmoil that has followed from that seminal event. She has creatively nested her voice within a variety of images, Mughal designs of India, Japanese painting and calligraphy, and now Persian manuscript illustrations from Jami's *Haft awrang* at the Freer Gallery of Art. With meticulous attention to the subtleties of line and color, Ms. Villard de Borchgrave studied each manuscript folio and selected elements that best captured and conveyed the spirit of her verses. Each page of *Beloved Spirit* sensitively juxtaposes a detail, whether a light soaked cloud, a tender sprig, or a lush blossoming flower, with a poem, subtly alternating rhythms of word and image and creating a harmonious whole.

Sultan Ibrahim Mirza's *Haft awrang* urges a perception of our world as one infused with the pervasive presence of the Divine. The pictorial elements that Ms. Villard de Borchgrave has selected from this illustrated text to accompany her poems in *Beloved Spirit* effectively remind us that the need to seek wisdom and consolation in words in images is as relevant today as it was in the sixteenth-century.

Massumeh Farhad
Chief Curator and Curator of Islamic Art
Freer Gallery of Art and Arthur M. Sackler Gallery

INTRODUCTION

On the night of September 11, 2001, as anguish hung in
the air like a veil of tears, I began to pray for a way to
bring some small measure of comfort to the families who
had suffered the most devastating loss of their loved ones.
Millions of fervent, desperate prayers go unanswered in this
increasingly distraught world, and my modest prayer years
ago also went unanswered.

Then, on the first anniversary of that day of sorrow, as I
watched the children call out their parents' names at Ground
Zero with a courage far greater than mine, a space opened in
my heart that made way for earnest verses about love, hope,
and courage to flow out of me. As I had never written poetry
before, I felt as if an unseen hand was guiding me down a
special path that, if I persevered, could lead to the fulfillment
of my prayer. The result three years later was the publication
of *Healing Light: Thirty Messages of Love, Hope and Courage*, a
collection of poetry illustrated with sixteenth-century
Indian Mughal Art paintings from the Freer and Sackler
Galleries of Art as well as from a number of other major
international museums. Copies were purchased through
the kindness of John C. Whitehead, then chairman of the
Lower Manhattan Development Corporation, and were
sent with a personal inscription of caring and respect to
all the families who had lost members on 9/11. And my
prayer was answered.

Two years later, with support from those who had found *Healing Light* to be soothing in troubled times, I wrote *Heavenly Order: Twenty Five Meditations of Wisdom and Harmony*, this time illustrated with the ethereal works of the seventeenth-century Japanese master painter Hon'ami Koetsu, also generously supplied by the Freer Gallery of Art.

Now, in this third endeavor to connect heartfelt reflections with beautiful images of the past, I have come to believe in an intimate moment of surrender, a time when the soul may connect with a higher being, light, spirit, or God, a part of which I am convinced resides within all of us. I believe this instance of release allows us to be open to creativity, take a step forward into the unknown, make untold mistakes along the way, and learn from them. It allows us to be vulnerable to sorrow, accepting of criticism and fosters a willingness to do better. It provides untapped courage in the face of terror and ultimately the peace with which to depart this life.

I also believe in Divine love and an eternal existence of the spirit. In this, I found these rare sixteenth-century Persian images from the Freer, the details of which I drew on for *Beloved Spirit*, to reflect the hidden harmonies of the world's creation as well as the flawless beauty of the infinite universe.

These stunning paintings by the finest artists of the day were inspired by the *Haft awrang* (*Seven Thrones*) manuscript by the renowned fifteenth-century mystic poet Abdul-Rahman Jami and commissioned by Prince Sultan Ibrahim Mirza (1540–77).

Just as it had occurred with *Healing Light* and *Heavenly Order*, it was a moving experience for me to discover inspirational connections with work from centuries ago with my own work today. For example, in Salaman and Absal, Folio 194b, which I took to illustrate the poem "Mercy," I found a soft echo in the story about lovers who flee the king's court to find an island of beauty and tranquility where they dwell in bliss. In my vision for "Mercy," which I depicted with a detail of windblown clouds, I wrote, "The fragrance of love fills the empty soul/ with mercy, forgiveness, to make man whole… /Let the rains cool the raging, fevered brows/ — drops of tenderness, mercy allows."

At this time of wearying world unrest and fragility, with tragically destructive natural disasters, I am deeply grateful to have been given the opportunity to draw on the beauty expressed in these images of the past. To me, this beauty reveals a way to find order in chaos and leads us in turn to an expression of universal clarity, compassion, love, and healing.

In the exquisite words of the great Sufi poet Rumi,

"Rise up! The painter of Eternity has set to work one more time.

To trace miraculous figures on this crazy curtain of the world.

God has lit a fire to burn the heart of the universe…"

Alexandra Villard de Borchgrave
Washington, D.C.

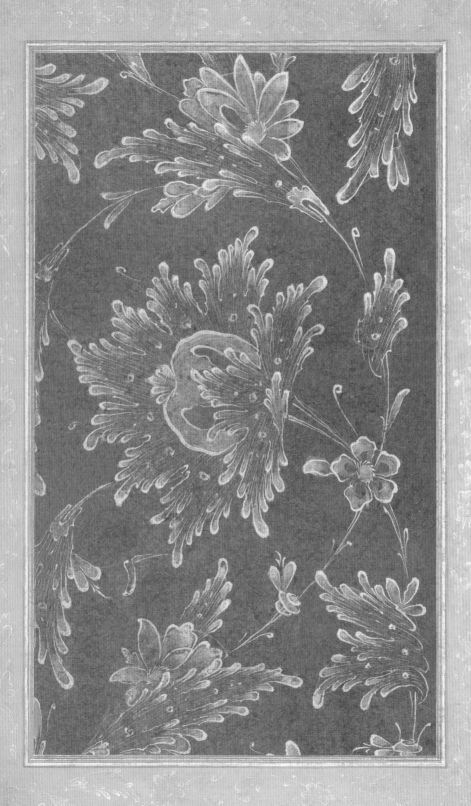

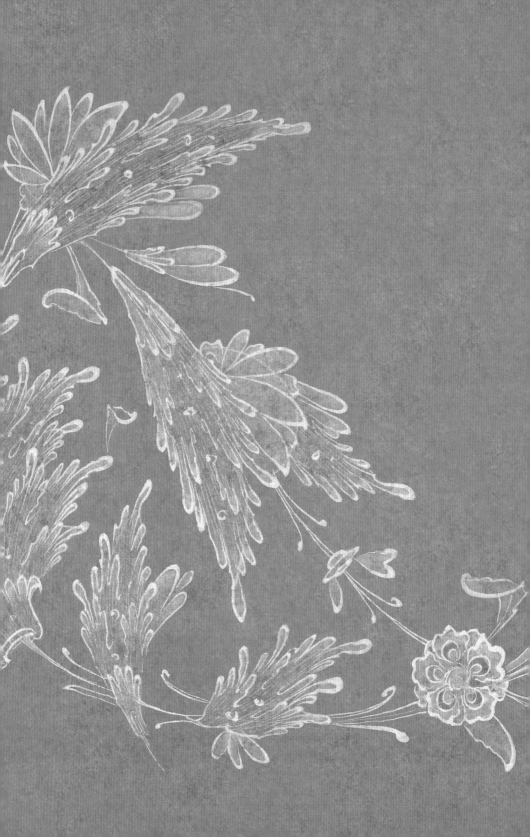

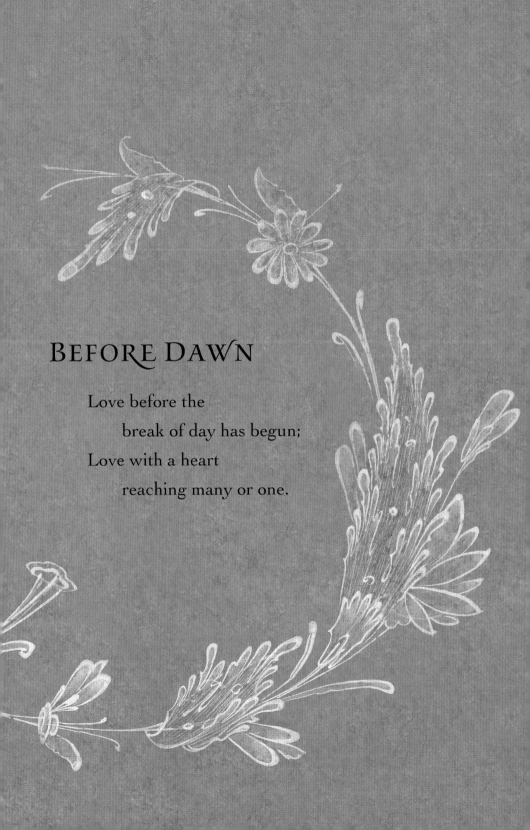

BEFORE DAWN

Love before the
 break of day has begun;
Love with a heart
 reaching many or one.

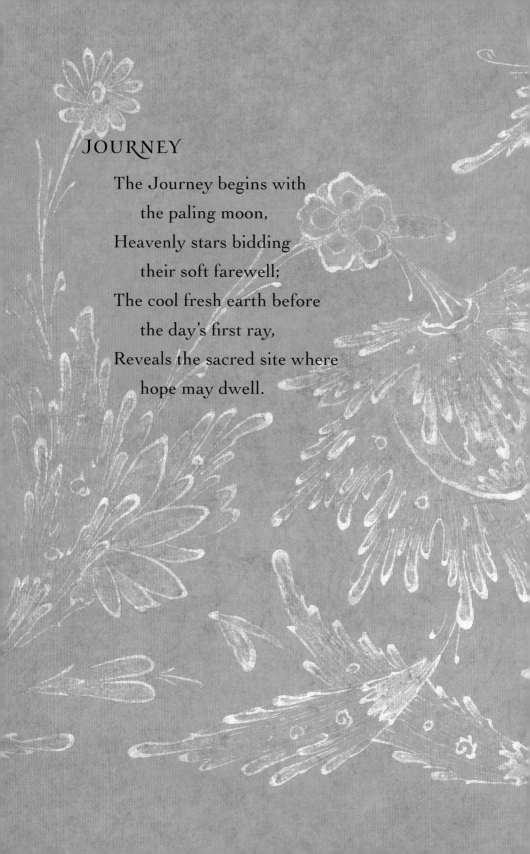

JOURNEY

The Journey begins with
 the paling moon,
Heavenly stars bidding
 their soft farewell;
The cool fresh earth before
 the day's first ray,
Reveals the sacred site where
 hope may dwell.

The stream of life carries
 the soul's desire,
Clear waves of truth lapping at
 steps of sand;
The tender light of
 the horizon's new dawn,
Draws the yearning heart to
 a distant land.

Though the wounds of life may
 haunt the spirit,
Unspeakable sorrow leaving
 ghosts of pain;
Abiding faith in
 the goodness of man,
Allows love to transcend
 this earthly plain.

LISTEN

Listen to the heart for the gift within,
Waken to the whispers of love therein.

Listen to the truth in songs without words,
Arise to the voices of morning birds.

Listen to the murmurs of faith and grace,
Stride bravely with the sun's brilliant pace.

Listen to the sorrow in storms' dark tears,
Go forth with the desire to quell deep fears.

Listen to the calling evening star –
All can be found in the spirit afar.

PATH

Wake to the shadows
of the night's last breath
as graces of light lift
their misty veil;
Gather up the silent
tendrils of dreams
to fashion the path
where love will prevail.

Though golden vines of passion
may entwine,
perfumed hyacinth cajole
and entreat,
Remain true to the rose's
pure white soul
with its scent of faith,
fragrant but discreet.

While sharp stinging nettles
of distress abound,
taunting the weary heart
once and again;
Live on as the rose's stem
— unbroken,
alive with courage and
honor to gain.

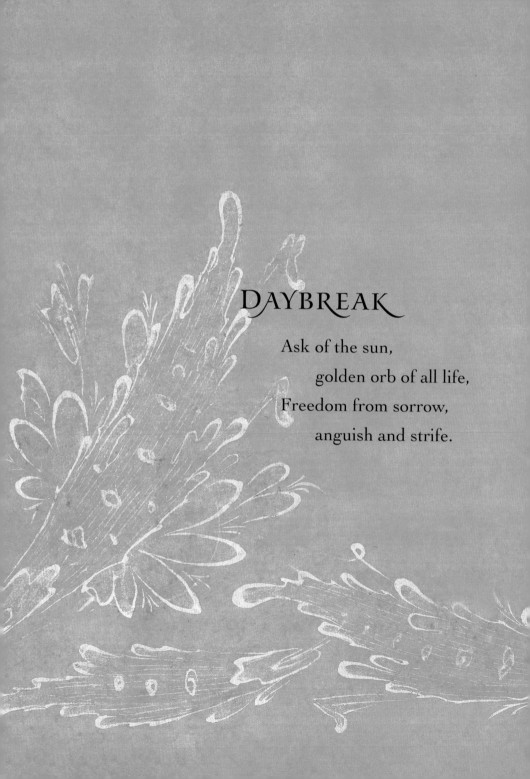

DAYBREAK

Ask of the sun,
golden orb of all life,
Freedom from sorrow,
anguish and strife.

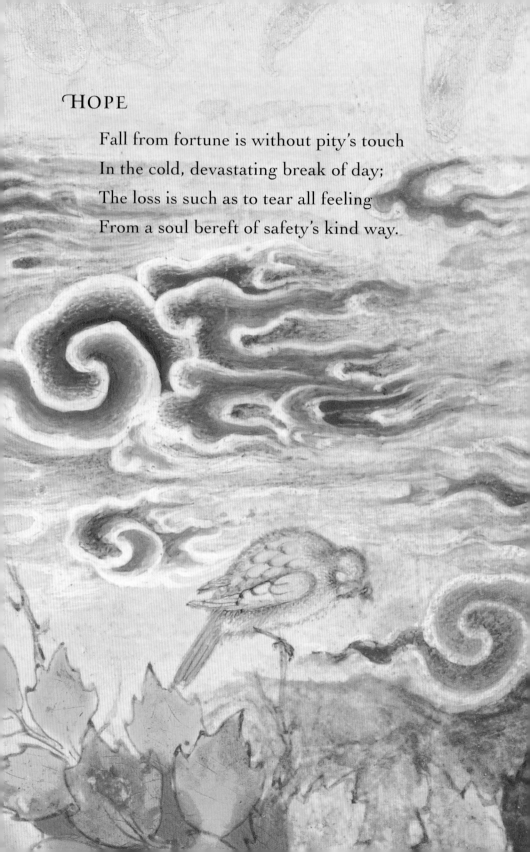

HOPE

Fall from fortune is without pity's touch
In the cold, devastating break of day;
The loss is such as to tear all feeling
From a soul bereft of safety's kind way.

Yet hope may be found in the heart's own strength,
Still stalwart and true on its lonely perch;
Persevere though gales of grief may mount,
As daring may open new paths to search.

Climb upward the steadfast boughs of courage,
To seek the sun's promise of splendid feats;
Let patience slay the clouds of doubt and fear
And win the starry goal hope's light completes.

Virtue

Humility and wisdom come with time;
 Waste not days searching for reason or rhyme.
Spend each born moment in thoughtful pursuit
 Of kindness, understanding, fine repute.

The highest mission of a life ordained
 Is to use precious gifts with pride regained.
Believe in the path set before thine eyes,
 Stay firm in virtue and gracious devise.

Greet the morning without fear or regret
 For golden new rays will pay the night's debt.
Open thy heart like a lustrous flower,
 To be filled with light beyond earth's power.

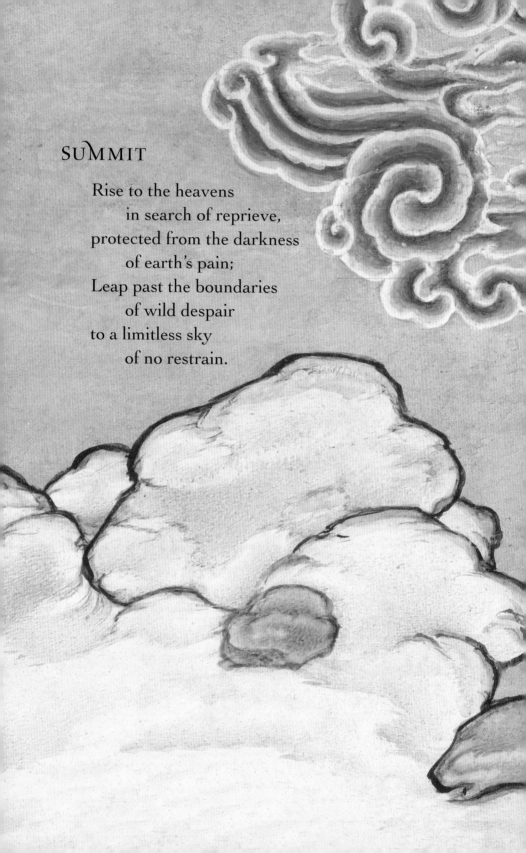

SUMMIT

Rise to the heavens
 in search of reprieve,
protected from the darkness
 of earth's pain;
Leap past the boundaries
 of wild despair
to a limitless sky
 of no restrain.

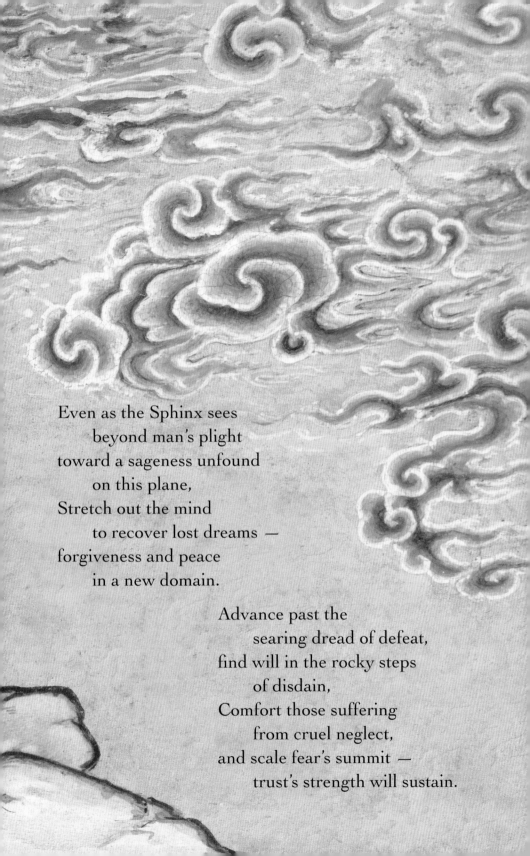

Even as the Sphinx sees
 beyond man's plight
toward a sageness unfound
 on this plane,
Stretch out the mind
 to recover lost dreams —
forgiveness and peace
 in a new domain.

Advance past the
 searing dread of defeat,
find will in the rocky steps
 of disdain,
Comfort those suffering
 from cruel neglect,
and scale fear's summit —
 trust's strength will sustain.

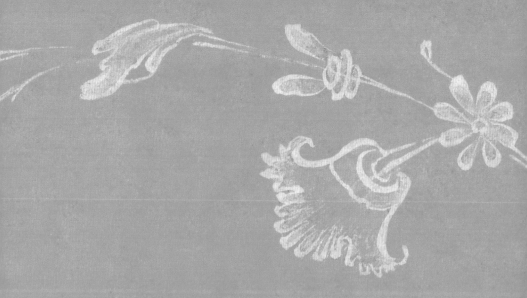

MIDDAY

Confront and endure
the furious heat
Of the day's most stringent
task to complete.

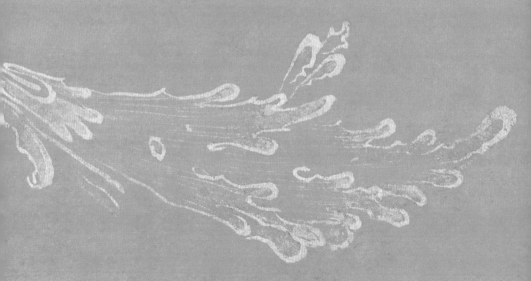

COURAGE

Ride with the wind where it may lead,

Through forests of anguish where spent hearts bleed.

Speed on and withstand the rising hot gale

Of dangerous deeds raining wicked hail.

Press forward with valiant currents of truth,

Strengthen the courage of the soul's lost youth.

Sweep over lakes of a thousand shed tears,

Spread the mantle of kindness over past ghostly fears.

Halt in the garden where virtue now grows,

Cultivate the stems of fresh healing prose.

Encircle the globe on a rush of joy,

Ride on, ride on with God's love to enjoy.

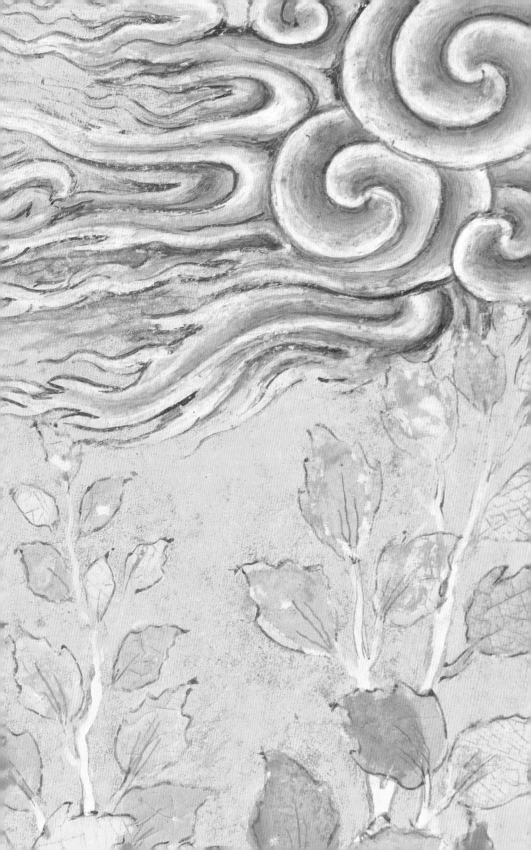

STILLNESS

When heartache strikes at the
core of the soul,
And the body is scorched by
torment's flame,
Then the heart will hold the
weight of all woes
In a refuge of peace of
untold fame.

In this blest retreat of
tranquil respite,
Where heaven exists in
luminous time,
There is no fear or agony
to feel,
Only love so great
there's no sin or crime.

The abandoned heart may
flounder and flail,
Like a wind tossed leaf in a
storm of tears;
Yet a shining stillness within
the eye
Offers shelter through
love's unending years.

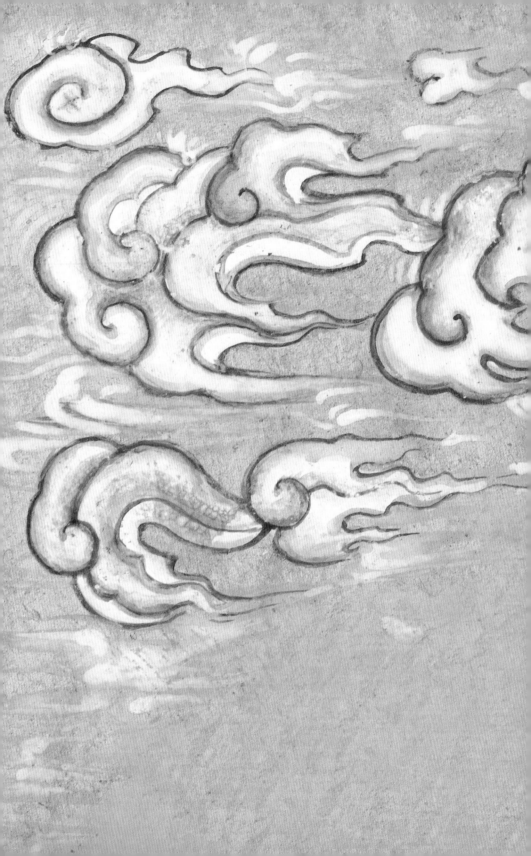

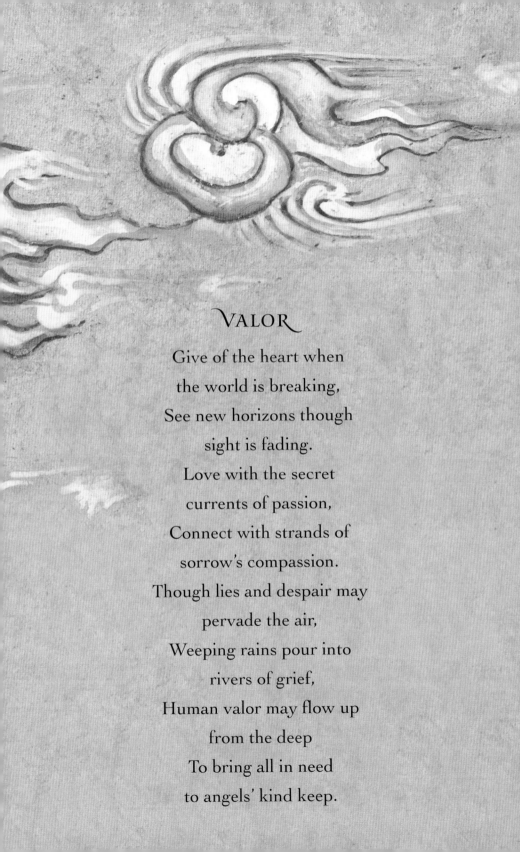

VALOR

Give of the heart when
the world is breaking,
See new horizons though
sight is fading.
Love with the secret
currents of passion,
Connect with strands of
sorrow's compassion.
Though lies and despair may
pervade the air,
Weeping rains pour into
rivers of grief,
Human valor may flow up
from the deep
To bring all in need
to angels' kind keep.

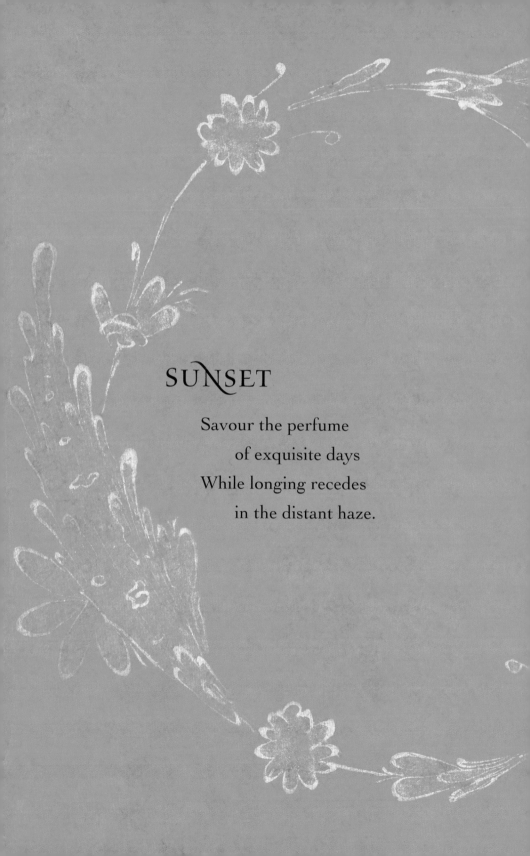

SUNSET

Savour the perfume
of exquisite days
While longing recedes
in the distant haze.

Ascent

Enter the raging path of fire
 To melt as one midst Life's desire.

 Swooning even in fearful dread,
 Render the soul with faithful tread.

Open the trembling, beating heart
 To gain the point at which to start.

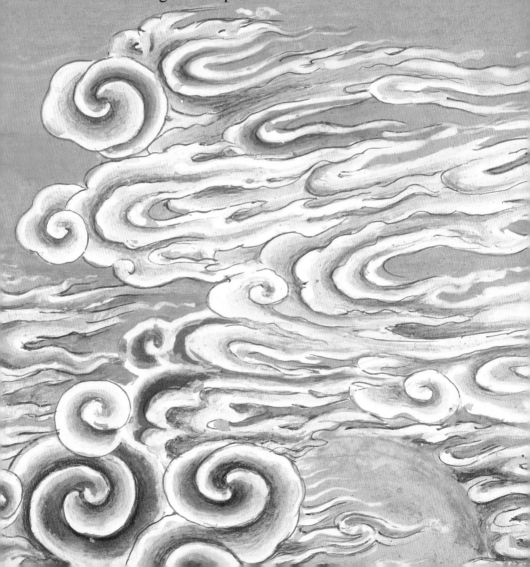

Delve deep inside that blessed place
 In which resides man's gift of grace.

 Raise high the sword of perfect trust
 To shield the eyes from evil's thrust.

And now with blazing, fine intent,
 Attain the noble, pure ascent.

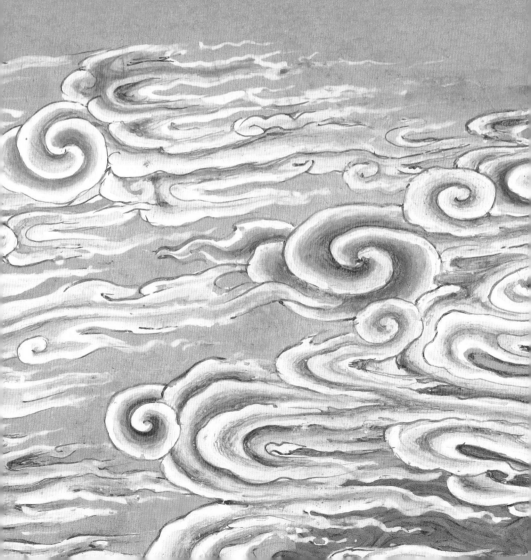

HUMANITY

What tragedy lies in the

setting clouds?

What crushed, ruined lives,

what damaged, sad crowds?

Humanity is noblest when the

chances are nil

To survive the worst of a

fate turned ill.

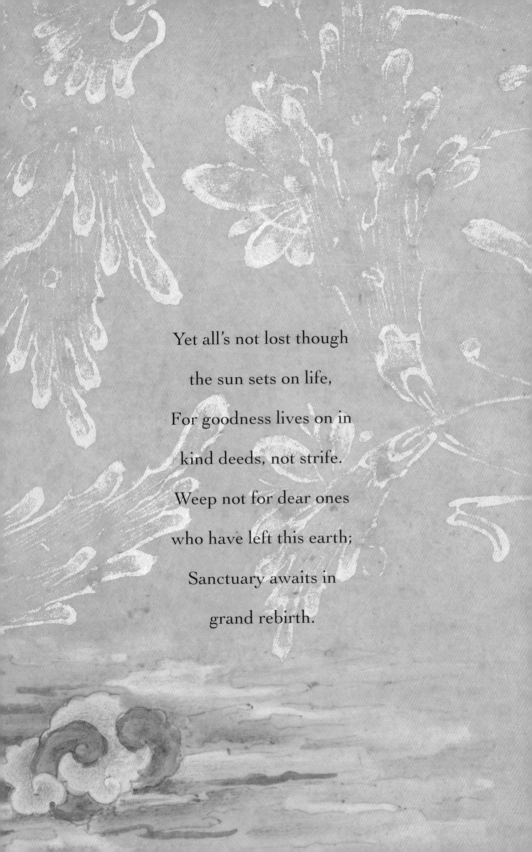

Yet all's not lost though
the sun sets on life,
For goodness lives on in
kind deeds, not strife.
Weep not for dear ones
who have left this earth;
Sanctuary awaits in
grand rebirth.

LOVE

Treasure a love that burns so fine
It defies the rule and passage of time;
Deeper than the sea, softer than a song,
Desire sees no fault in rapture sublime.

Like a single white star emerging at night
In the vastness of an immortal joy,
The dream will survive in eternal love,
No human error or death may destroy.

Pure silken threads lace the heavens' line
In homage to the dying crimson sun;
And the light carries the heart beyond all grief
To a love, undenied, two souls as one.

MERCY

The fragrance of love fills the empty soul

with mercy, forgiveness to make man whole.

Forgo all vengeance lest it strike the heart,

leaving sorrow, destruction, love torn apart.

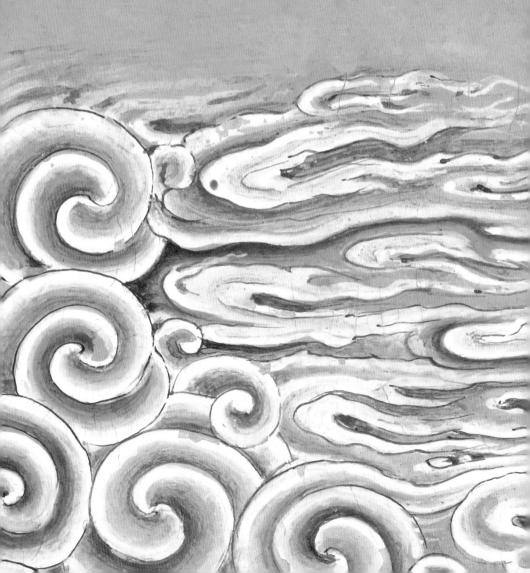

Misery and splendor live side by side,

 in a restless world of ruthless divide.

Now the breath of freedom in search of truth,

 may bear the honor of the world's new youth.

Let the rains cool the raging, fevered brows

 — drops of tenderness, mercy allows.

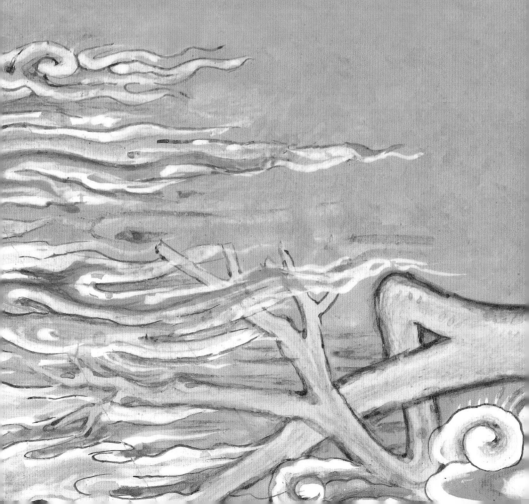

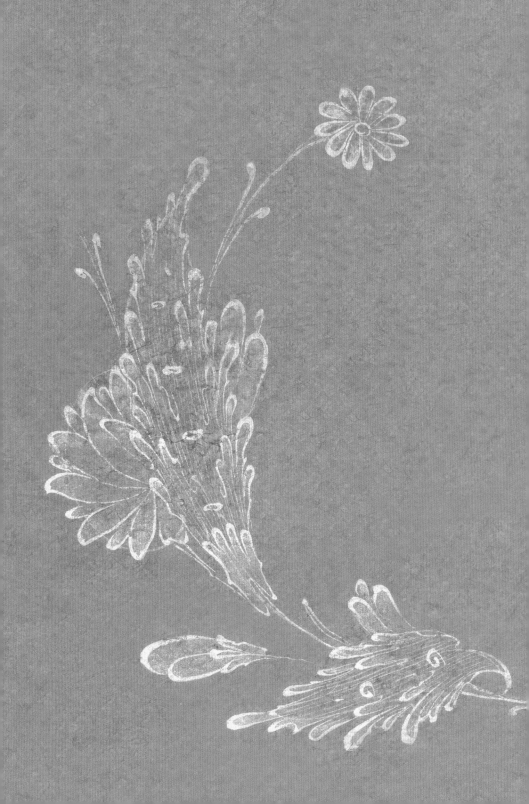

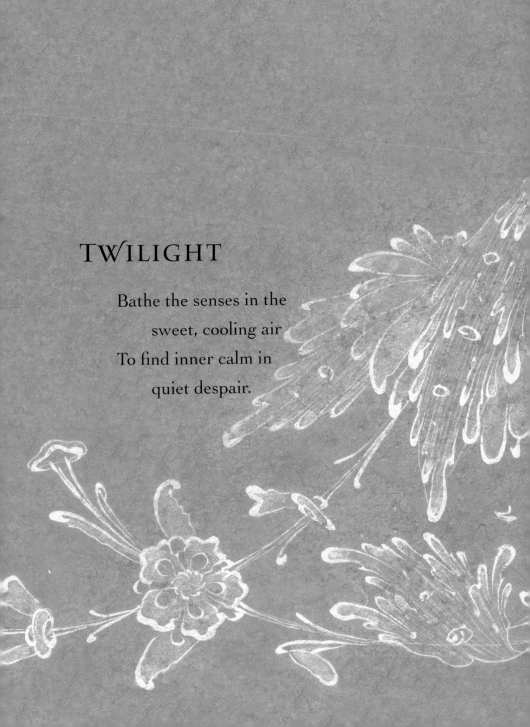

TWILIGHT

Bathe the senses in the
sweet, cooling air
To find inner calm in
quiet despair.

PRAYER

Call forth the messenger
on wings of gold
to light the heavens
for all to behold.

Release the stars from
their velvety bed
to guard our journey through
life's joy and dread.

Send down the seraphs
to gather our dreams
to make a new world
of grace that redeems.

Bless our passion
for love beneath the sun
to bring hearts and Spirit
to live as one.

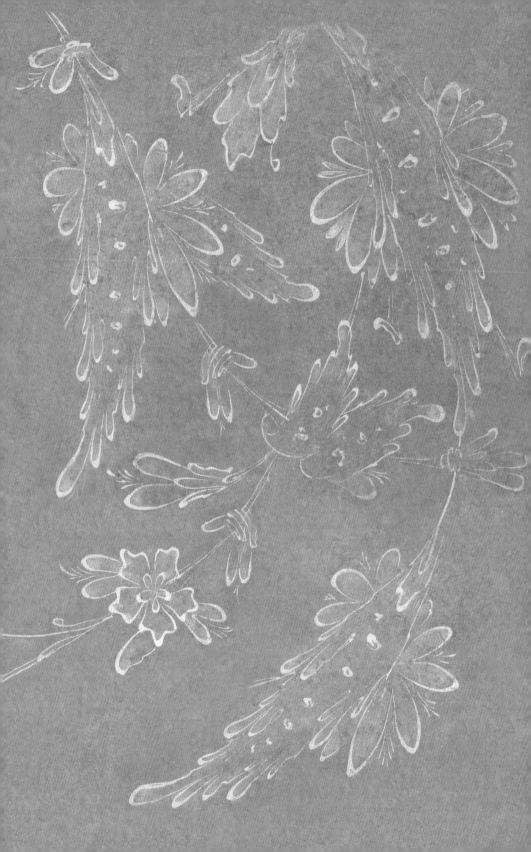

HARMONY

There is such a point
of infinite light
Where the sun and the moon
wed in times of old,
And the night and the day
become as one —
A chalice of joy
too dazzling to hold.

With glittering stardust
on silver clouds,
Radiant harmony
surrounds the soul,
And a life too fragile for
earth's harsh mold,
Is inscribed on Heaven's
most cherished scroll.

In a timeless place of
no hour or land,
Where the soul is free
to seek soaring dreams,
The heart will know the
true secret of life —
To steer love to others
by gracious means.

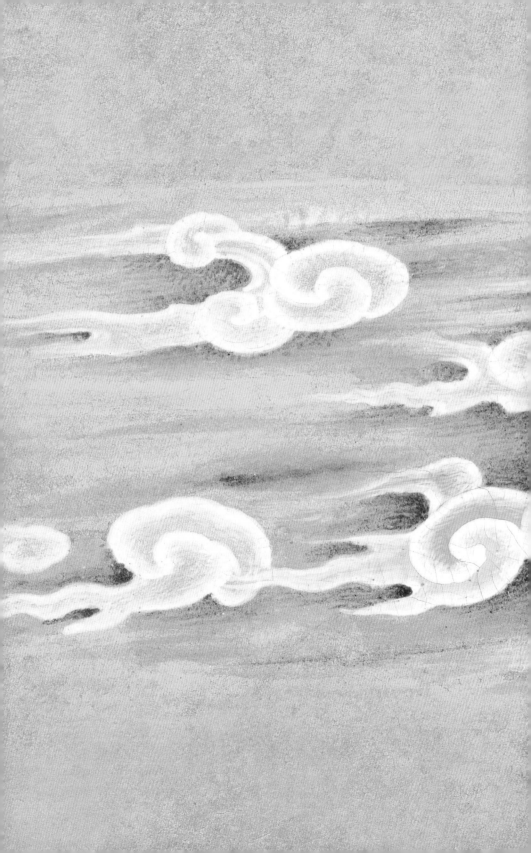

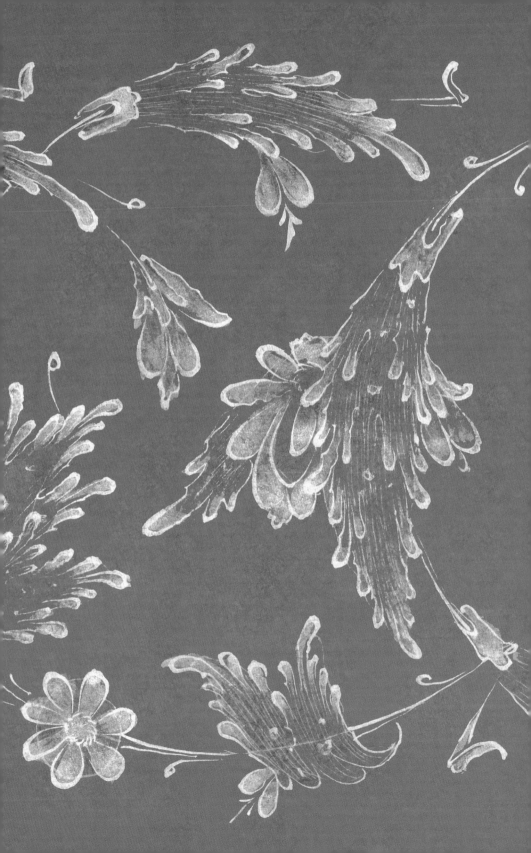

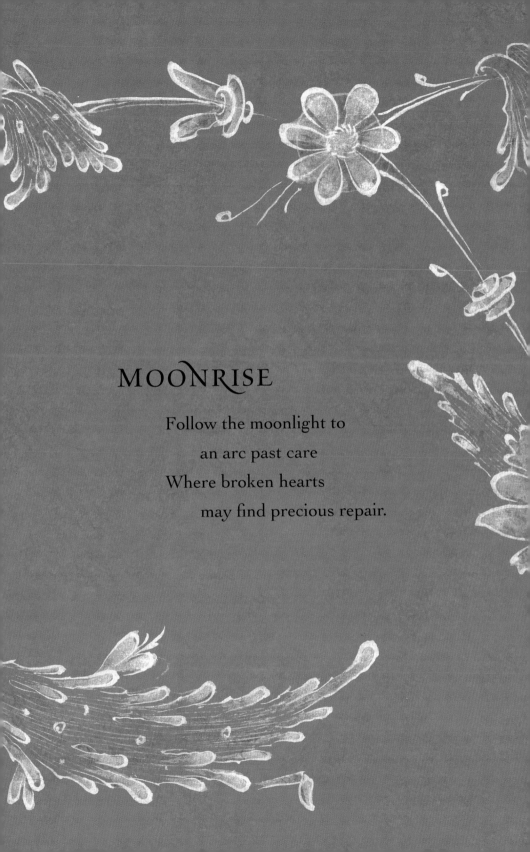

MOONRISE

Follow the moonlight to
 an arc past care
Where broken hearts
 may find precious repair.

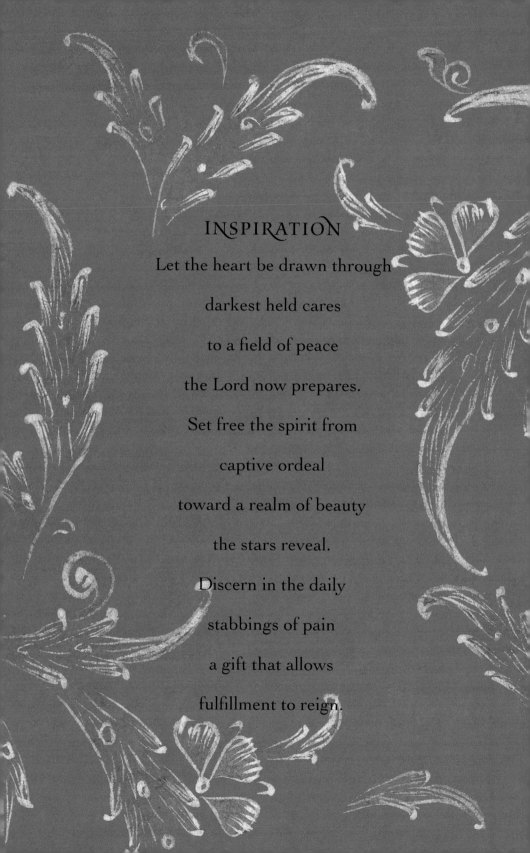

INSPIRATION

Let the heart be drawn through

darkest held cares

to a field of peace

the Lord now prepares.

Set free the spirit from

captive ordeal

toward a realm of beauty

the stars reveal.

Discern in the daily

stabbings of pain

a gift that allows

fulfillment to reign.

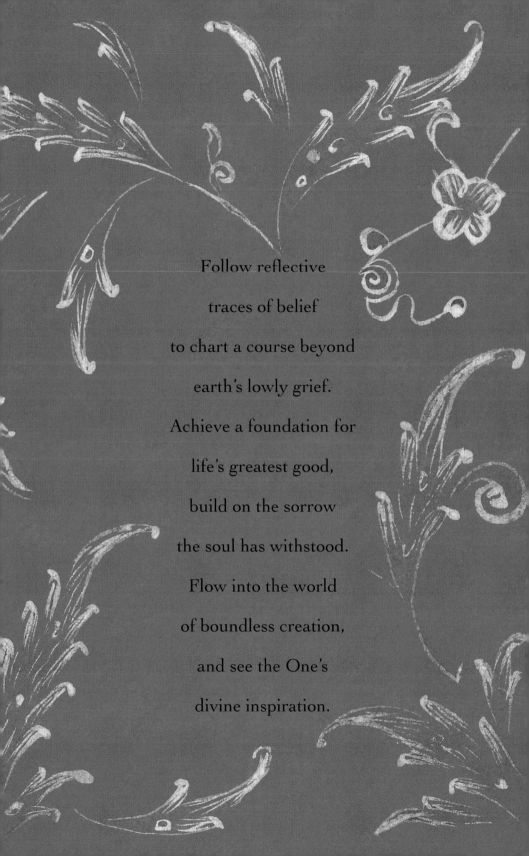

Follow reflective

traces of belief

to chart a course beyond

earth's lowly grief.

Achieve a foundation for

life's greatest good,

build on the sorrow

the soul has withstood.

Flow into the world

of boundless creation,

and see the One's

divine inspiration.

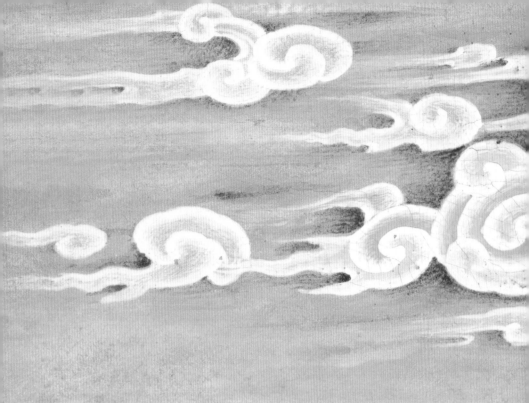

DREAMS

Look to the moon, fair witness to the world,
True guide to the sight of Heaven unfurled;
Fear not the darkness of night's vast display,
But keep woes of the heart safely at bay.

Draw on the spark from profound ancient thought,
Illuminate fine dreams the great gods sought;
Desire the knowledge of unknown times past,
Emerge with a glimmering of wisdom's repast.

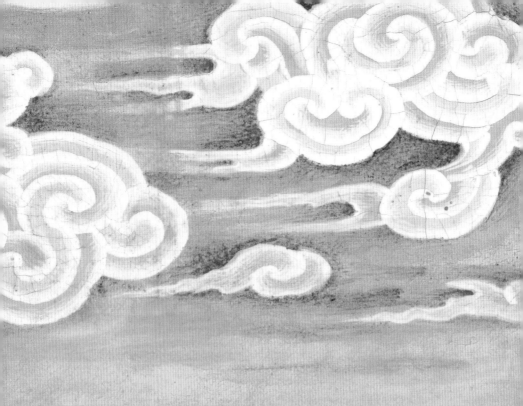

Stand high on the mast of the ship of fate,
Navigate rough waters in steady state;
Search out the sea beyond life's endurance,
Captivate kingdoms with quiet assurance.

Follow the stars, East, North, and West,
Discover new realms on Zeus's wild crest;
Soar through the skies with an eagle's sight
To be one with Beloved's burning light.

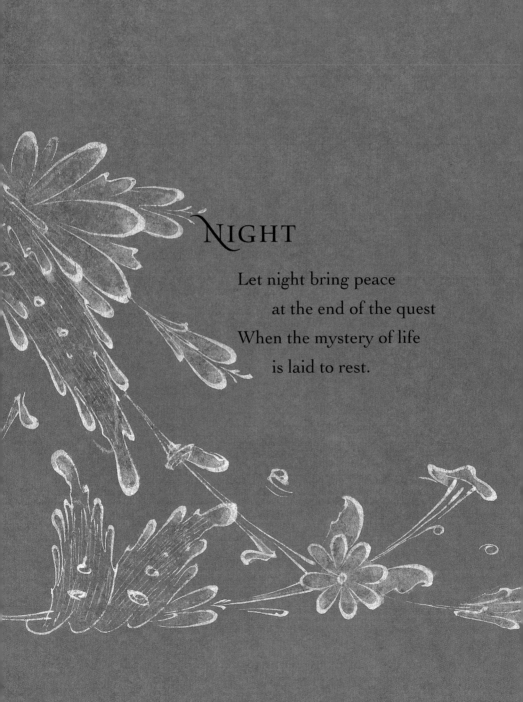

NIGHT

Let night bring peace
at the end of the quest
When the mystery of life
is laid to rest.

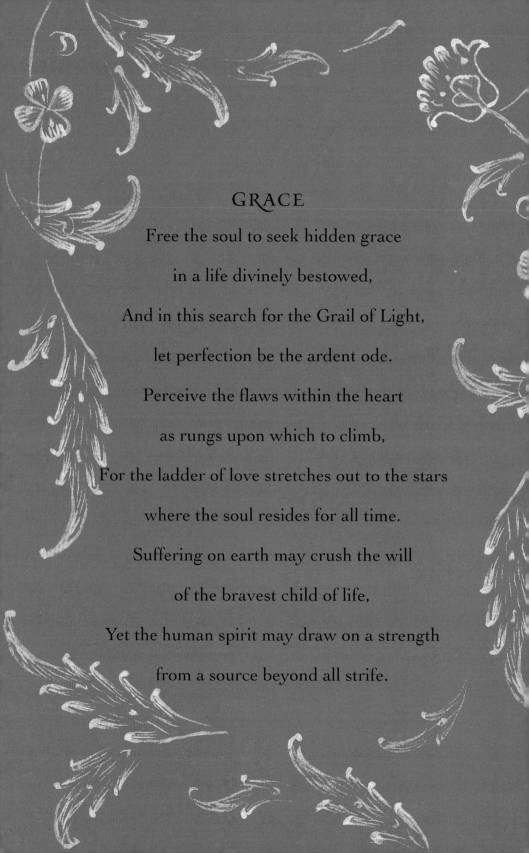

GRACE

Free the soul to seek hidden grace

in a life divinely bestowed,

And in this search for the Grail of Light,

let perfection be the ardent ode.

Perceive the flaws within the heart

as rungs upon which to climb,

For the ladder of love stretches out to the stars

where the soul resides for all time.

Suffering on earth may crush the will

of the bravest child of life,

Yet the human spirit may draw on a strength

from a source beyond all strife.

PEACE

A moment may come at the rarest time,
 When the moon turns to gold and stars to pearls,
And the soul in need gains a precious sphere
 Of healing peace free of perilous swirls.

On this half way path to angelic heights,
 When the light and dark dissolve into mist,
Hatred and jealousy are cast aside
 And shades of love find reason to exist.

Carry onward the gentle standard of worth,
 Love first all others beyond self or land;
Then brightness will surely fill this sad world,
 Bringing forth new greatness as once was planned.

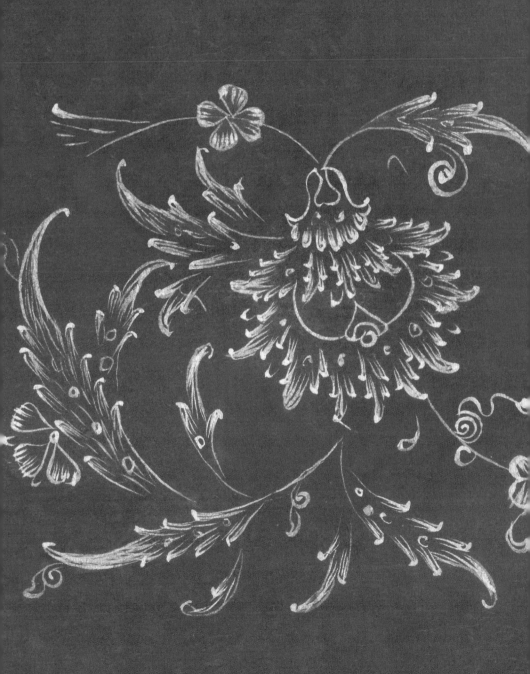

MIDNIGHT

Leave the soul to be cleansed
by Nature's hand,
Tears now halted
by a higher command.

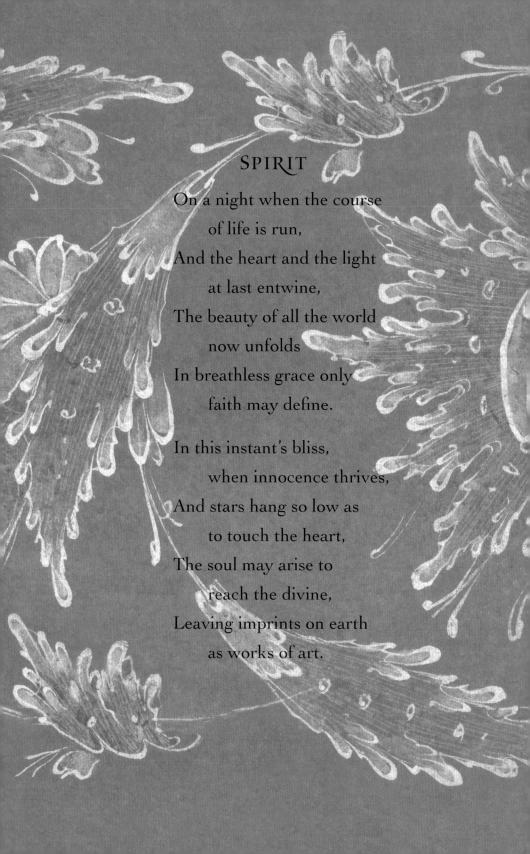

SPIRIT

On a night when the course
 of life is run,
And the heart and the light
 at last entwine,
The beauty of all the world
 now unfolds
In breathless grace only
 faith may define.

In this instant's bliss,
 when innocence thrives,
And stars hang so low as
 to touch the heart,
The soul may arise to
 reach the divine,
Leaving imprints on earth
 as works of art.

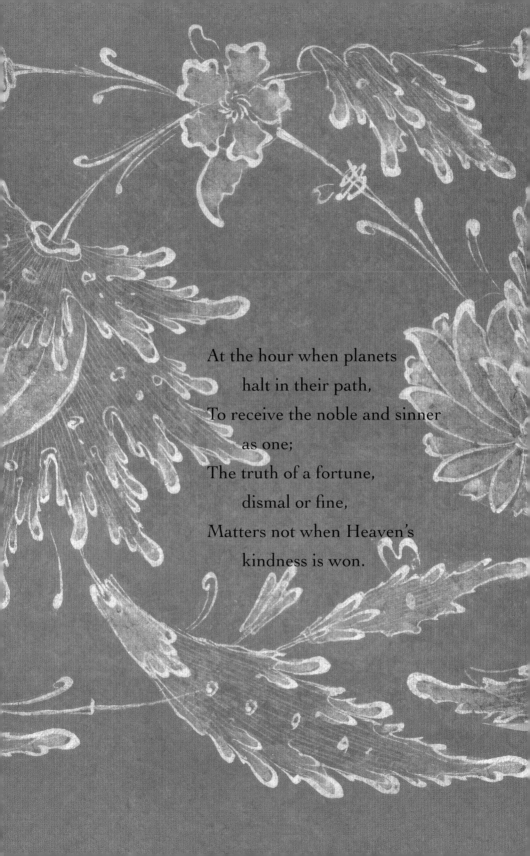

At the hour when planets
 halt in their path,
To receive the noble and sinner
 as one;
The truth of a fortune,
 dismal or fine,
Matters not when Heaven's
 kindness is won.

ARTWORK

ARTWORK

All artworks are copyright © Freer Gallery of Art, Smithsonian Institution, Washington DC.

Gift of Charles Lang Freer

All images featured in *Beloved Spirit* are details of Folios from the *Haft awrang* (Seven thrones) by Jami (d. 1492) Probably Mashad, Khurasan, Iran, Safavid period, 1556–1565

ARTWORK

Khurasan School
Ink, opaque watercolor and gold on paper
H × W: 34.2 × 23.2 cm
(13 7/16 × 9 1/8 in)
Purchase Freer Gallery of Art
F1946.12.270a

HALF TITLE PAGE

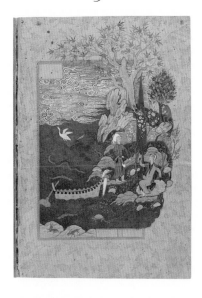

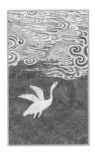

Salaman and Absal repose on the
happy isle
Khurasan School
Opaque watercolor, ink and gold on paper
H × W: 34.2 × 23.2 cm
(13 7/16 × 9 1/8 in)
Purchase Freer Gallery of Art
F1946.12.194b

TITLE PAGE

Salaman and Absal repose on the
happy isle
Khurasan School
Opaque watercolor, ink and gold on paper
H × W: 34.2 × 23.2 cm
(13 7/16 × 9 1/8 in)
Purchase Freer Gallery of Art
F1946.12.194a

BEFORE DAWN

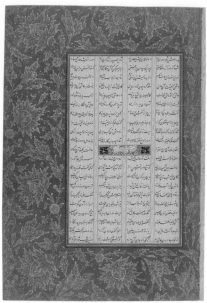

Khurasan School
Ink, opaque watercolor and gold
on paper
H × W: 34.2 × 23.2 cm
(13 7/16 × 9 1/8 in)
Purchase Freer Gallery of Art
F1946.12.61a

JOURNEY & ACKNOWLEDGMENTS

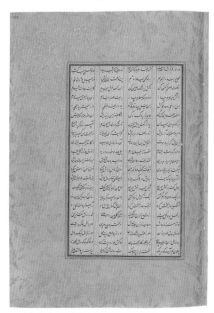

Khurasan School
Ink, opaque watercolor and gold on paper
H × W: 34.2 × 23.2 cm
(13 7/16 × 9 1/8 in)
Purchase Freer Gallery of Art
F1946.12.270a

LISTEN

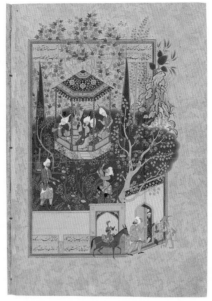

The townsman robs the villager's orchard
Khurasan School
Opaque watercolor, ink and gold on paper
H×W: 34.2 × 23.2 cm
(13 7/16 × 9 1/8 in)
Purchase Freer Gallery of Art
F1946.12.179b

PATH

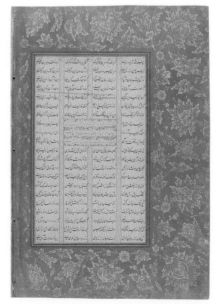

Khurasan School
Ink, opaque watercolor and gold on paper
H×W: 34.2 × 23.2 cm
(13 7/16 × 9 1/8 in)
Purchase Freer Gallery of Art
F1946.12.144b

Daybreak

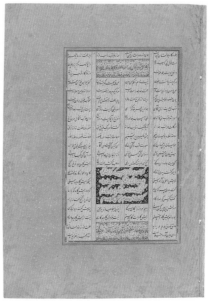

Probably Mashad, Khurasan, Iran,
Safavid period, 1556–1565
Khurasan School
Ink, opaque watercolor and gold on paper
H × W: 34.2 × 23.2 cm
(13 7/16 × 9 1/8 in)
Purchase Freer Gallery of Art
F1946.12.57a

Hope

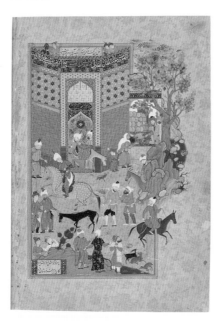

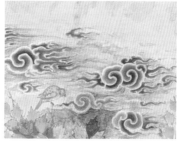

The simple peasant entreats the salesman
not to sell his wonderful donkey
Khurasan School
Opaque watercolor, ink and gold on paper
H × W: 34.2 × 23.2 cm
(13 7/16 × 9 1/8 in)
Purchase Freer Gallery of Art
F1946.12.38b

VIRTUE

Khurasan School
Ink, opaque watercolor and gold on paper
H × W: 34.2 × 23.2 cm
(13 7/16 × 9 1/8 in)
Purchase Freer Gallery of Art
F1946.12.78b

SUMMIT

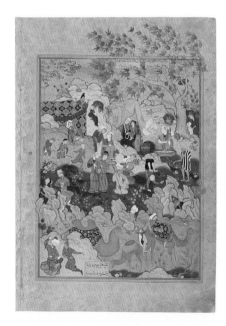

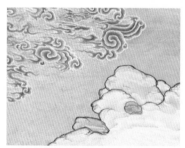

A depraved man commits beastiality and
is berated by satan
Khurasan School
Opaque watercolor, ink and gold on paper
H × W: 34.2 × 23.2 cm
(13 7/16 × 9 1/8 in)
Purchase Freer Gallery of Art
F1946.12.30a

MIDDAY

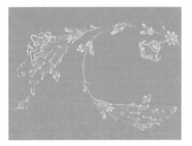

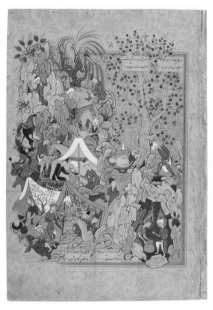

Yusuf Is rescued from the well
Opaque watercolor, ink and gold on paper
H×W: 34.2 × 23.2 cm
(13 7/16 × 9 1/8 in)
Purchase Freer Gallery of Art
F1946.12.105a

COURAGE

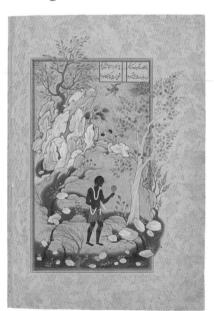

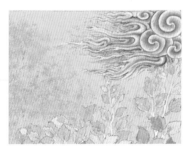

The East African looks at himself in
the mirror
Sultan Ibrahim Mirza
Opaque watercolor, ink and gold on paper
H×W: 34.2 × 23.2 cm
(13 7/16 × 9 1/8 in)
Purchase Freer Gallery of Art
F1946.12.221b

STILLNESS

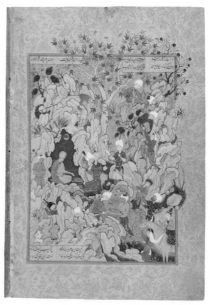

The Pir rejects the ducks brought
as presents

Opaque watercolor, ink and gold on paper

H × W: 34.2 × 23.2 cm
(13 7/16 × 9 1/8 in)

Purchase Freer Gallery of Art
F1946.12.153b

VALOR

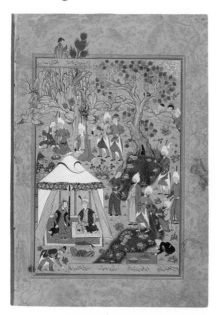

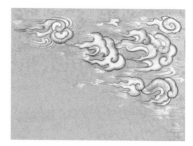

Khusraw Parviz and Shirin deal with
the fishmonger

Opaque watercolor, ink, and gold on paper

H × W: 34.2 × 23.2 cm
(13 7/16 × 9 1/8 in)

Purchase Freer Gallery of Art
F1946.12.291

SUNSET

Khurasan School
Ink, opaque watercolor and gold on paper
H × W: 34.2 × 23.2 cm
(13 7/16 × 9 1/8 in)
Purchase Freer Gallery of Art
F1946.12.78a

ASCENT

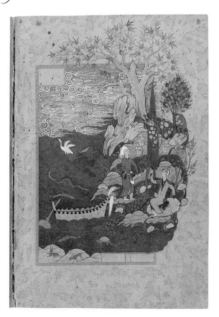

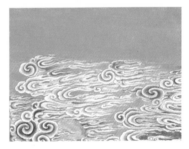

Salaman and Absal repose on the
happy isle
Khurasan School
Opaque watercolor, ink and gold on paper
H × W: 34.2 × 23.2 cm
(13 7/16 × 9 1/8 in)
Purchase Freer Gallery of Art
F1946.12.194b

HUMANITY

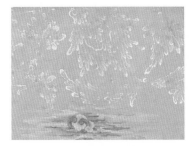

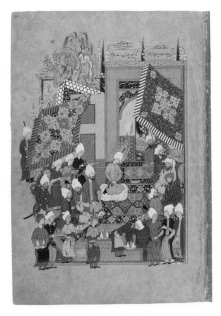

Yusuf gives a royal banquet in honor
of his marriage
Khurasan School
Opaque watercolor, ink and gold on paper
H × W: 34.2 × 23.2 cm
(13 7/16 × 9 1/8 in)
Purchase Freer Gallery of Art
F1946.12.132a

LOVE

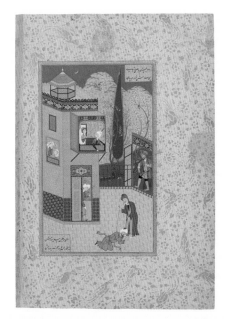

The Murid kisses the Pir's feet
Opaque watercolor, ink and gold on paper
H × W: 34.2 × 23.2 cm
(13 7/16 × 9 1/8 in)
Purchase Freer Gallery of Art
F1946.12.207b

MERCY

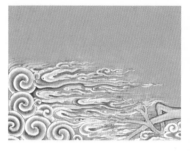

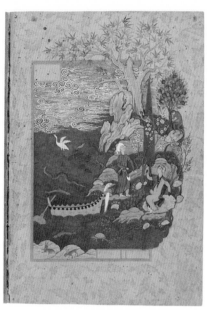

Salaman and Absal repose on the happy isle
Khurasan School
Opaque watercolor, ink and gold on paper
H × W: 34.2 × 23.2 cm
(13 7/16 × 9 1/8 in)
Purchase Freer Gallery of Art
F1946.12.194b

TWILIGHT

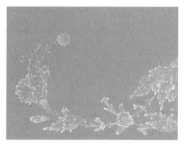

Khurasan School
Ink, opaque watercolor and gold on paper
H × W: 34.2 × 23.2 cm
(13 7/16 × 9 1/8 in)
Purchase Freer Gallery of Art
F1946.12.008b

HARMONY

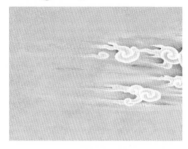

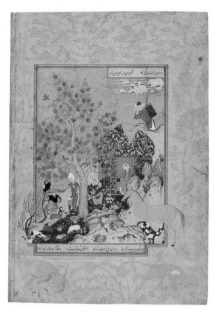

Yusuf tends his flocks
Opaque watercolor, ink and gold on paper
H × W: 34.2 × 23.2 cm
(13 7/16 × 9 1/8 in)
Purchase Freer Gallery of Art
F1946.12.110b

PRAYER & MOONRISE

Khurasan School
Ink, opaque watercolor and gold on paper
H × W: 34.2 × 23.2 cm
(13 7/16 × 9 1/8 in)
Purchase Freer Gallery of Art
F1946.12.053a

DREAMS

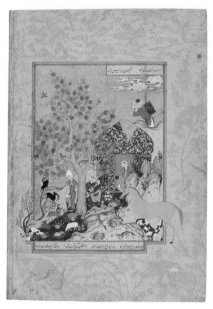

Yusuf tends his flocks

Opaque watercolor, ink and gold on paper

H × W: 34.2 × 23.2 cm

(13 7/16 × 9 1/8 in)

Purchase Freer Gallery of Art

F1946.12.110b

INSPIRATION & GRACE

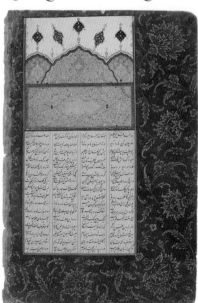

India, Mughal period, 18th–19th century

Ink, opaque watercolor and gold on paper

H × W: 34.2 × 23.2 cm

(13 7/16 × 9 1/8 in)

Purchase Freer Gallery of Art

F1946.12.001b

Night

Khurasan School
Ink, opaque watercolor and gold on paper
H × W: 34.2 × 23.2 cm
(13 7/16 × 9 1/8 in)
Purchase Freer Gallery of Art
F1946.12.053a

Peace

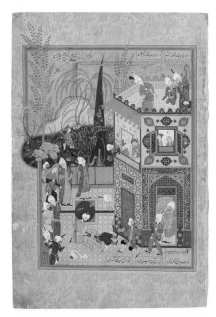

The Fickle Old Lover is Knocked Off
the Rooftop
Opaque watercolor, ink and gold on paper
H × W: 34.2 × 23.2 cm
(13 7/16 × 9 1/8 in)
Purchase Freer Gallery of Art
F1946.12.162a

MIDNIGHT

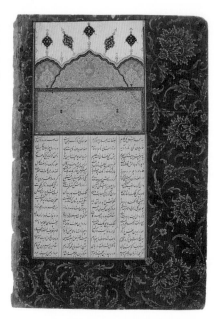

India, Mughal period, 18th-19th century
Ink, opaque watercolor and gold on paper
HxW: 34.2 x 23.2 cm
(13 7/16 × 9 1/8 in)
Purchase Freer Gallery of Art
F1946.12.1

SPIRIT

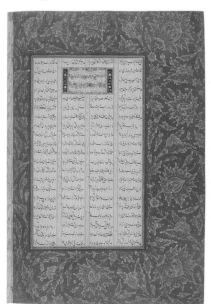

Khurasan School
Ink, opaque watercolor and gold on paper
HxW: 34.2 × 23.2 cm
(13 7/16 × 9 1/8 in)
Purchase Freer Gallery of Art
F1946.12.88

ENDPAPERS

Majnun comes before Layli disguised
as a sheep
Khurasan School
Opaque watercolor, ink and gold on paper
H × W: 34.2 × 23.2 cm
(13 7/16 × 9 1/8 in)
Purchase Freer Gallery of Art
F1946.12.264b

COVER

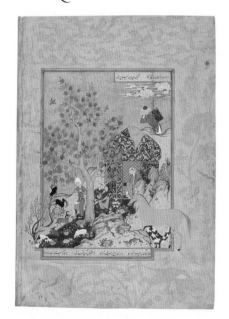

Yusuf tends his flocks
Opaque watercolor, ink and gold on paper
H × W: 34.2 × 23.2 cm
(13 7/16 × 9 1/8 in)
Purchase Freer Gallery of Art
F1946.12.110b

ACKNOWLEDGMENTS

Acknowledgments

I am deeply grateful for all the kindness that has allowed me to complete the trilogy of books I began on the night of September 11, 2001 with *Healing Light*, continued with *Heavenly Order*, and have finished today with *Beloved Spirit* to commemorate the tenth anniversary of that day of sorrow.

Healing Light, *Heavenly Order* and now *Beloved Spirit* would not have been possible without the unique permission I was granted by the Freer and Sackler Galleries of Art to place my words inside the images from their extraordinary collections of rare manuscripts.

First and foremost, I would like to express my gratitude to Dr. Julian Raby, the Director of the Freer and Sackler Galleries of Art, for his unfailing courtesy and generous support for my work, not to mention untold meetings to review my progress and to give me the benefit of his far-reaching vision.

I would also like to thank Dr. Massumeh Farhad, Chief Curator and Curator of Islamic Art, most especially for her gracious guidance with *Beloved Spirit* through the complex process of selection and presentation of details from the sixteenth-century paintings commissioned by Prince Sultan Ibrahim Mirza (1540–77).

I owe the beauty of the images in all three books to the marvelous eye of Neil Greentree, the Freer's immensely talented photographer, and I cannot thank him enough for his extraordinary contributions.

I would also like to thank Dr. Debra Diamond, Associate Curator of the South and Southeast Asian Art collection, for being the first to support my ideas and for her warm friendship through the years.

I am grateful to all the staff of the Freer and Sacker Galleries of Art for their many kindnesses over the years, including Marjan Adib, Louise Caldi, Elizabeth Damore, Cory Grace, David Hogge, Emily Glasser, Carol Huh, Jay Kaveeshwar, Joe Macedo, Sarah Nolan, Kathryn Phillips, Chris Popenfus, Jennifer Ryan, Yue Shue, James T. Ulak, Rachel Wood, Reiko Yoshimura, and Katie Ziglar.

I would like to express my deepest and most heartfelt thanks to my dear friend and *nonpareil* publisher, Marta Hallett, of Glitterati Incorporated, for believing in my work when we first began our collaboration shortly after the first anniversary of 9/11. I am enormously grateful to Marta for bringing her uniquely creative ideas to bear on the completion of this trilogy and for her enthusiastic support over so many years. My thanks also go to the devoted Glitterati team, Jessica Guerrero, Gayatri Mullapudi, and Angella Beauvais, for their kind support.

I could not have married all my words with the images in this book without dear Marta Kapoyos, whose fine hand with the graphics and warmhearted support saw me through the project, and I cannot thank her enough for all her patient hours of work by my side.

My warmest thanks to talented designer Henrique Siblesz, who ably created the layout for *Heavenly Order* and has once again applied his sure hand to the same task with *Beloved Spirit*.

I owe Julian Waters a true debt of gratitude for his special typographic designs and the charm he has brought to each title in *Beloved Spirit*.

My thanks on the graphics in *Beloved Spirit* also go to consulting designer Marty Ittner for her lovely ideas.

I am indebted to the museums and their wonderful staff who contributed to *Healing Light* and I would like once again to thank them for their generous support. They include, The British Museum; The British Library; Christie's Images; The Cleveland Museum of Art; The Los Angeles County Museum; The Metropolitan Museum of Art; The Musée Guimet; The National Gallery of Art; The National Gallery of Victoria; The Reitberg Museum; The Royal Asiatic Society; Sotheby's; and The Victoria and Albert Museum.

I cannot imagine being able to write *Beloved Spirit*, as well as the others, without the loving support of my wonderful family, most especially my beloved husband, Arnaud, and dear brother Dimitri and sister-in-law, Xue Er Villard.

There are many cherished friends and esteemed colleagues who have so kindly put aside their own work, without a single complaint, to encourage me with mine, and I thank them here with all my heart. They are just too numerous to name on these few pages, but I think of them constantly and am forever grateful for all their kindness and generosity.

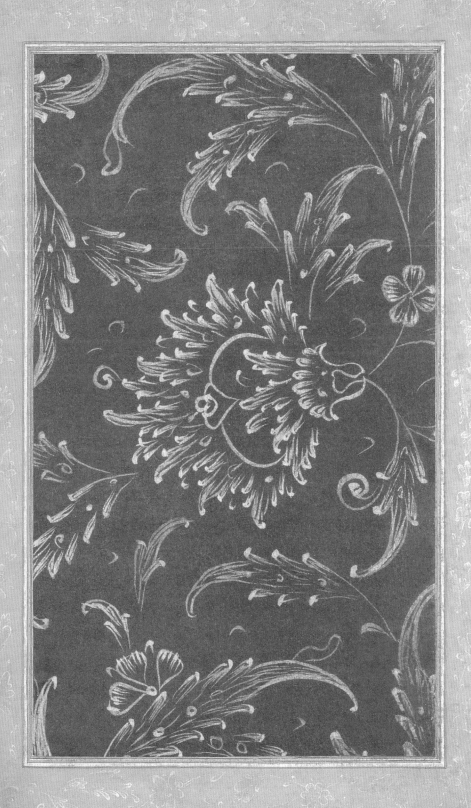

Alexandra Villard de Borchgrave has built a reputation as a photojournalist, author, and poet over the past forty years. Her photographs have appeared on the covers of internationally renowned publications, such as *Newsweek* and *Paris Match*. She is the co-author of *Villard: The Life and Times of an American Titan* (Nan A. Talese/Doubleday), a biography of her great grandfather, railroad magnate and financier Henry Villard, who masterminded the creation of General Electric. Alexandra Villard de Borchgrave is also the author of *Healing Light: Thirty Messages of Love, Hope, and Courage* and *Heavenly Order: Twenty Five Meditations of Wisdom and Harmony* (Glitterati Incorporated). She currently serves on the Board of the Blair House Restoration Fund and the Advisory Committee of the Asia Society. She is a graduate of Sarah Lawrence College and lives with her husband in Washington, D.C.

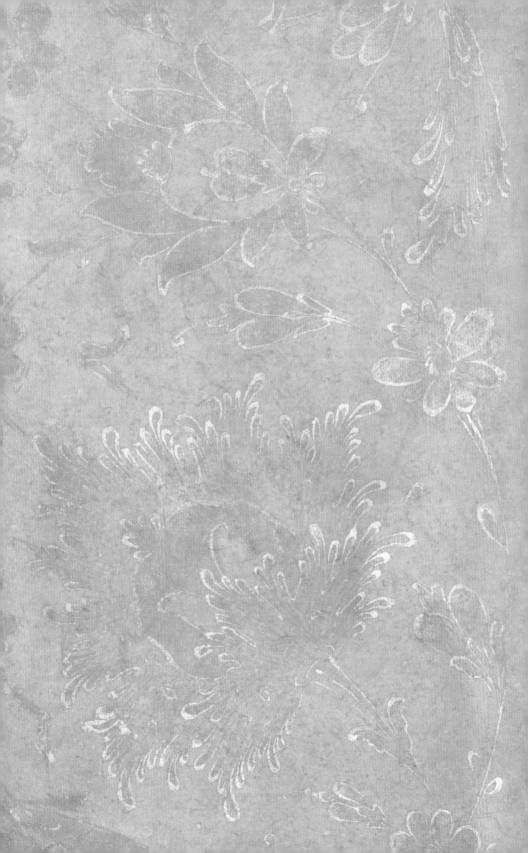

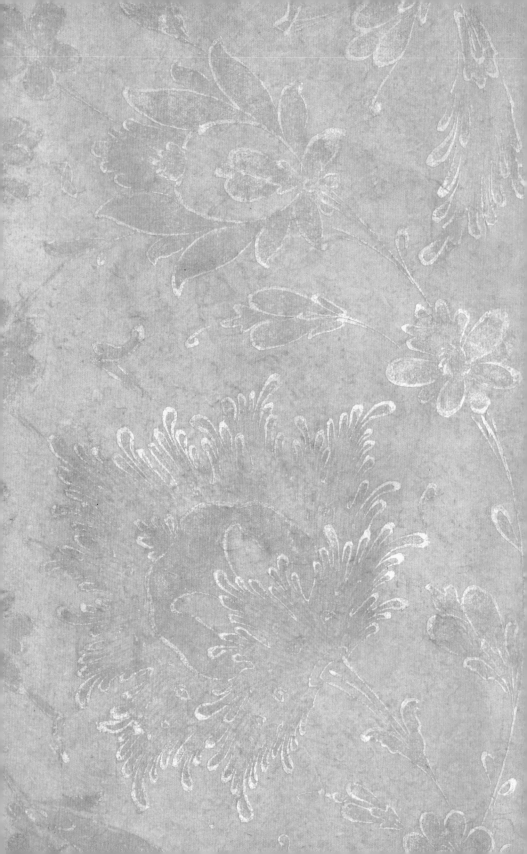